JN084296

RYOSUKE UEHARA

植原亮輔／KIGI

変容の受け皿

柔らかいけど無骨、軽やかなのにどっしり、都会的でありながら野生が見え隠れする。ぼくが植原さんに抱くイメージは、彼のデザインにも直結している。『この星の光の地図を写す』という、自分の集大成でもある展覧会のビジュアルをKIGIにお願いしたいと思い至ったのは、それまで彼らの仕事の一端に触れてきて、きっと自分に新鮮な驚きをもたらしてくれるだろうと思ったからで、その期待は、一条の光と共に想像以上のクリエイションをもって返ってきた。以後、自分の展示が行われる各地の美術館に二人は何度か足を運んでくれて、都度、立ち話をするのだが、自分の大切なものを差し出してそれをしっかりと受け止めてくれた人として、話していて安心感があった。大地に根差した大きな二つの木に見守られているような、穏やかな気持ちになれたのだ。

それから一年が経った頃だろうか、ぼくは植原さんに個人的に連絡をしてお会いする機会を得た。外国の仕事を終えて帰国し、空港からそのまま代官山のカフェに来てくれた植原さんに、ぼくはまた一つのお願いを申し出た。これもまた自分の人生において最も大切にしてきた世界最高峰エベレストと二番目に高いK2という山で撮影し続けてきた写真をまとめて本にしたい、という相談である。一冊は通常の大きさの写真集だが、もう一冊はビッグブックと呼ばれる机ほどもある特大本を作るという依頼で、後者は本という体裁でありながら、モノとしての存在感は、書籍という枠を軽く飛び越えている。できあがったビッグブックは、大海原を悠々と泳ぐエイのような佇まいだった。荒々しさがありながら鋭い針先を持つような繊細なデザインは、実に植原さんらしいと思った。二冊のヒマラヤの写真集は、おかげさまで自分にとっても楔となる記念碑的な作品になった。

宇都宮美術館での展示や、最近の鏡を使った写真作品を見ても感じるのは、日常的に見るもの、特別ではないもの、ありふれた景色を、いとも簡単にひっくり返し、驚きを与えてくれる術の鮮やかさである。子どもの頃、マッチ棒を並べ替えて動物の形を作ったりするパズルのような遊びが好きだったのだが、植原さんはまさにマッチ棒から何でも作ってしまう近所のお兄さんのような存在だ。指をパチンと鳴らすと風景が変わってしまう、そんな前触れのない変容。プライベートワークも含めた彼のクリエイションには、マジックのような新鮮な驚きを禁じ得ない。

『この星の光の地図を写す』もエベレストやK2の写真も、大袈裟ではなく、ぼくの生き方そのものと言ってもいい作品で、それを世に問うにあたってふさわしい仲介者として、ぼくはKIGIであり、植原さんにお願いした。自分の名前は「真っ直ぐな樹」という意味だが、安心できる二本の大木のそばで、どうにかこうにか自分も立ちあがり、森のように絡み合ってまた共に作品を作っていけたらいいなあ、と思っている。

石川直樹 / 写真家

Transformational Recipient Tender yet rugged; light yet weighty; urbane but with intermittent traces of wildness. The images I embrace of Ryosuke Uehara are directly connected to his design works also. The reason I requested KIGI to prepare the visual design for "Capturing the Map of Light on This Planet," the exhibition representing the culmination of my works to date, was because I had seen some of their work and felt they would surely inject a fresh element of surprise into my body of works. My expectations were rewarded with creativity beyond anything I could have imagined, a true ray of light. After that initial collaboration, on several occasions Mr. Uehara and Ms. Watanabe visited my traveling exhibition at art museums here and there around Japan. Each time we would take time to chat, and whenever I showed them something that was important to me, they would respond thoughtfully, so our conversations always gave me a sense of security. Their reaction always had a calming effect on me, as though I were being protected by two large trees firmly rooted in the Earth.

About a year after that, I contacted Mr. Uehara and had a chance to meet with him on a casual level. He was just returning from a job overseas and came directly from the airport to the café in Daikanyama where I was waiting. I made yet another request of him. I wanted to put together two books of my photos taken over the years at Mount Everest and K2, the highest and second-highest peaks in the world which had a position of utmost importance in my life, and I asked for Mr. Uehara's help. One volume was to be a large photo book of standard size, and the other I wanted to be an extra-large coffee table type book. With the latter in particular, though in format a book, I was eager to make something that would go beyond the framework of a book and have a presence all its own. The coffee table book that Mr. Uehara came up was like a stingray swimming majestically through ocean waters. Its design was precisely what I expected of Mr. Uehara: finely detailed, and combining roughness with the sharpness of a stinger. Thanks to his artistry, my two photo books of the Himalayas became two works that marked a monumental inflection point in my career.

Seeing KIGI's exhibition at the Utsunomiya Museum of Art or their recent works created with use of mirrors, I am struck by their fresh skill in taking everyday items, items having nothing special about them, or ordinary vistas, and, ever so simply, turning them upside-down and infusing them with an element of surprise. When I was a child, I was fond of playing with puzzles in which you create animal shapes using matchsticks, and to me Mr. Uehara is like an older playmate who can create anything from matchsticks. With him, vistas undergo change at the snap of his fingers, resulting in an unanticipated transformation. His creations, including his private works, have a magical sense of fresh surprise.

Without exaggeration, "Capturing the Map of Light on This Planet" and my photos of Everest and K2 are works that embody my very way of life; and to serve as the intermediary for bringing them to the public I selected Mr. Uehara and KIGI. The characters that make up my name, Naoki, mean "a straight tree." Leaning on the two trees giving me security – KIGI, which is written as "two trees" – I receive the strength to stand tall as an integral part of a forest. I look forward to working with them again in the future. Naoki Ishikawa / Photographer

We took great care in
making each one
individually by hand,
using cover paper
left over from
the production of
notebooks by
Japanese makers of
stationery products.
But we feel that our
vases go best with
mass-produced
artificial flowers
which are
on sale for ¥100.
They don't
need water.

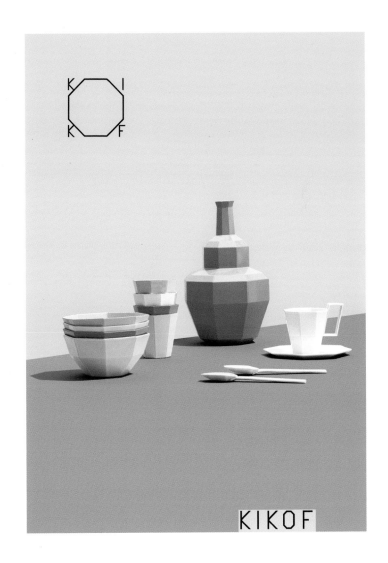

KIKOF

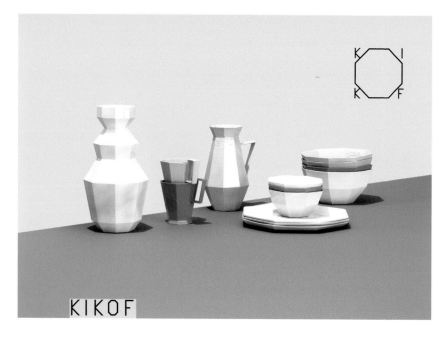

KIKOF

PROJECT① KIKOF

2014年11月、KIKOFは誕生した。東京・青山にあるスパイラルにて約1ヶ月間の展覧会を行い、陶器製品を中心として木工家具や布製品なども発表。そして2021年現在もKIGIと丸滋製陶を中心にブランドを継続的に運営している。この仕事は、ブランドのロゴ、ポスター、プロダクト、展示の空間などが高く評価され、めでたく2015年度の東京アートディレクターズクラブ（東京ADC）のグランプリを受賞することができ、滋賀の職人たちとともに喜びを分かちあうことができた。「MOTHER LAKE PRODUCTS」というプロジェクトを立ち上げて、職人たちとつながり滋賀のものづくりを応援する活動をしていた立命館大学の佐藤典司先生からの依頼でこのプロジェクトは始まった。2011年の年末、ちょうどKIGIの設立の準備をしているときだった。佐藤先生との出会いは講師で招かれた台湾でのワークショップがそのきっかけで、その後も何度かお会いする機会があり、約2年後に正式な依頼を受けた。当時、都道府県のブランド力調査をしたところ滋賀県はなんと47位。最下位という不名誉な位置づけに嘆く県の職員さんが佐藤先生に相談したのがことの始まりだったのだ。京都の隣に位置する滋賀県は京都文化を支える地域の1つでもある。商人文化によって栄えたり、琵琶湖を利用した運送や交通の要衝の地でもあるが、ものづくりによって繁栄してきたこともまた滋賀県の特徴でもある。ところが近代化が進むにつれて次第に需要が減り、せっかく育て上げた技術を継承することが難しくなってきたという。常に光のあたる京都の影となり、当時の僕は滋賀について琵琶湖以外何も知らず、"最下位のブランド力"について、違和感なく佐藤先生からの話を聞いていた。また、先生のお話から、僕にはデザイン力とアートディレクターとしての展開力を期待されたように感じた。ただ、職人とのものづくりの経験はそれまで数例しかない。普段はデザインを優先してそれにあった製法を探すようなつくり方をしている。"職人や製法が初めから決まっているデザイン"には咄嗟に難しさを感じたが、様々な技術を持つ職人がメンバーにいるので、面白いことができるのでは？と、少し期待感を持ち、

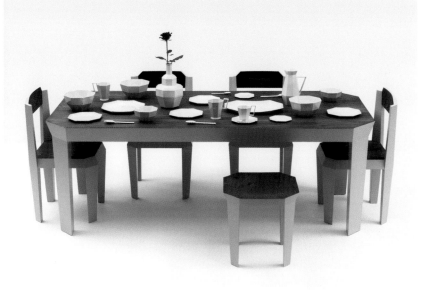

PROJECT① KIKOF

KIKOF was born in November 2014. For roughly one month, we mounted an exhibition of KIKOF brand products at SPIRAL in Tokyo's Aoyama area, mainly featuring ceramic ware but also including wood furniture, cloth products, etc. Today, in 2021, the KIKOF brand continues to flourish largely through the collaboration of KIGI and Marushi Porcelain. Our KIKOF work has been highly acclaimed, not just for the brand's products but also for its logo, posters, exhibition layouts, and more. In 2015, it was selected by the Tokyo Art Directors Club (Tokyo ADC) to receive that organization's Grand Prize, an honor that we were pleased to share with our collaborating partners, the artisans of Shiga Prefecture. The KIKOF project began after I was approached by Noriji Sato of Ritsumeikan University, who was engaged in promoting craftsmanship in Shiga through ties with local artisans and the launch of the "Mother Lake Products" project. The invitation came late in 2011, just as I was preparing to establish KIGI. I had made Mr. Sato's acquaintance at a workshop in Taiwan to which I had been invited to speak. We met on several occasions after that, and it was around two years later that he formally approached me. At the time, a survey of the brand power of Japan's 47 prefectures had just been completed, and Shiga had finished dead last. Things then set in motion after craftspeople from Shiga, lamenting their prefecture's woeful survey showing, approached Mr. Sato for advice. Shiga Prefecture is situated to the immediate east of Kyoto, and for generations it has played a role in sustaining Kyoto's culture. Shiga has historically thrived especially on its merchant culture, and it also served as a transport and transportation hub using Lake Biwa. But Shiga Prefecture has also been distinguished for its own thriving crafts culture. Modernization, however, has resulted in a gradual decline in demand for its skills, and its prowess developed over the centuries is now said to face a lack of successors to carry it forward. At the time, I myself had little knowledge about Shiga. The prefecture has always been in the shadow of Kyoto, and all I knew about Shiga was that it is home to Lake Biwa. So it came as no surprise to me when Mr. Sato spoke of Shiga's finishing last in the survey of prefectural brand power. From what Mr. Sato said, I gathered that he was pinning his hopes on my strengths as both a designer and art director. But up until that time I had had only minimal experience working creatively with artisans. Normally, in my creative process I give highest priority to the design and then search for a suitable production method. As

キコ7

KIKOF_PLATE_01

Lake Biwa, filled to its brim with water,
is a "large Japanese bowl"

琵琶湖は日本の大きな器である。

"KIKOF" is a product brand that came about as a result of
activities connected with the Mother Lake Products Project.
Products are jointly developed by KIGI — creative artists
based in Tokyo whose diverse activities include graphics,
products and fashion — and artisans working in traditional
crafts based around Lake Biwa in Shiga Prefecture.

KIKOF KIKOF

渡邉良重（わたなべよしえ）も誘ってKIGIの初めての仕事として取り組んでみることにした。約1年半は思考とコミュニケーション、そして試作に時間を費やし、スタートして2年の期間を経てブランドを立ち上げることができた。

実は、一度プレゼンをしたアイデアを自らやり直すということがあった。最初は、職人みんなに参加してもらえるようバランスを考えながら、上代20〜30万円はするであろう結婚をテーマにしたセット商品の提案をした。プレゼンは盛り上がったものの、どこか自分の中で消化不良を感じていた。いつか出会った職人が話したことを思い出した。デザイナーは高いお金をかけてスーパーカーをつくり、去っていく。残されたメーカーや職人たちはどう売ってよいか分からなくなり、結局一時的な話題になるだけで終わってしまう。苦労して捕まえた獲物を空から勢いよく降りて奪い、骨と皮だけ残して食べ去っていくハゲタカのようだと。僕は同じことをしようとしてないか？そもそも、アートディレクターは問題解決をする仕事でもあると先人たちから教わってきた。この仕事の一番の目的は、滋賀のブランド力を上げること、工場や職人たちの育て上げた技術を継承すべく、僅かでもよいので曇り空に一条の光を差し込むことである。そう考えて、プレゼン後の帰りの新幹線で方針を変えることにした。手の届かない"スーパーカーをつくる"のではなく、"愛され続けるブランドをつくる"こと。そのためには、手に取りやすい陶器の器がよいのではないか。「琵琶湖は日本の大きな器である」というコピーを掲げて、1stプロダクトとして信楽の丸滋製陶と陶器製品をつくる。そして世の中の流れやブランドとしての体力などを見ながら徐々に製品を増やしていく。さらに、いただく予定だったデザイン料の受け取りを断り、そのお金をブランド設立のための資金にさせてもらい、また、リスクも利益もシェアをするかたちで、ともにブランドを運営していくことにした。

such, I immediately sensed it would be difficult to design something whose craftspeople and production method were fixed from the outset. But since the project members were to include artisans with diverse technical skills, my expectations were raised somewhat. Perhaps this would lead to something interesting, I thought. I invited Yoshie Watanabe on board and decided to give the project a try, as KIGI's first job. Yoshie and I spent the next year and a half mulling over possibilities, communicating our ideas, and making prototypes. It was a full two years from the start that we were finally able to launch our KIKOF brand.

Truth be told, at one point I decided to start from scratch again after I had already made a presentation of our proposal. Initially I was thinking of achieving balanced participation by all artisans taking part in the project, and I proposed a set of merchandise on a marriage theme that would cost between 200,000 and 300,000 yen retail. Though the presentation had generated considerable enthusiasm, somehow the whole thing didn't sit right with me. I recalled what an artisan I once met had said to me: that designers all want to design supercars; they want to design a supercar at great expense and then their responsibility ends there. In the designer's wake are left the craftspeople and manufacturer who are at a loss how to sell such a product, and in the end the project goes unfinished. The prize they took such pains to acquire ends up like the skin and bones left after a swarm of vultures has swooped down from the sky at great speed, grabbed the tasty meat, and left nothing to chew in their wake. Wasn't I guilty of doing the same thing? From my predecessors I had always been taught that the job performed by an art director is to solve problems. The primary purpose of the job I had been engaged to undertake was to enhance Shiga's brand power, to shed a ray of light into the murky skies of Shiga's artisans and small factories, so that the skills they had developed over time might be passed on to the future. Mulling this over in my mind as I sat in the bullet train on my way back to Tokyo after the presentation, I decided to shift directions. Instead of creating a "supercar" beyond everyone's reach, I decided to develop a brand that would be widely loved, today and tomorrow. To achieve that, I thought perhaps the answer rested in creating porcelain items accessible to everyone. As the first product, I suggested making porcelain tableware together with Marushi Porcelain, a local producer of Shigaraki ware pottery. After that, we could gradually add other products while monitoring market trends and the popularity achieved by our brand itself. I further decided to refrain from accepting the fee I would receive for my design work, instead allocating that money to serve as capital for establishing the brand. In this way, by sharing both risks and benefits, I was determined to operate the KIKOF brand as a partner.

PROJECT②　酔独楽

古くは土佐の地方に「可杯（べくはい）」という"飲み干さないと置けない"天狗のお面
の盃があった。それは手のひらに収まるくらいのお面を裏返して酒器として使う。鼻が
高くて大きいので、酒を沢山入れることはできるが、当然平らな接地面がないので置くこと
ができない。また、ひょっとこのお面の盃もあり、口に穴があいてるので、指でおさえ
ながら飲み干さなくてはいけない。これらは酒の席でのコミュニケーションツールとして
親しまれてきた。僕は現代の発想で可杯をつくろうと、接地面がない先端が尖った円錐
形の盃を考え、独楽（こま）のように回ることをこの盃の大きな特徴とし、メーカーの
D-BROS、そして2つの県にまたがる伝統工芸の職人らとともに、2017年の春頃から
開発を進めていた。その年の秋、新潟で3年に一度開催される「大地の芸術祭 越後妻有
アートトリエンナーレ2018」で一般公募が行われていることを知り、KIGIとして何か
参加できないか考えてみた。公募していたのはメイン会場であるキナーレで行われる
「方丈記私記」という企画展示。ここでは、鴨長明の『方丈記』から、1つの解釈として
"方丈（四畳半）に宇宙を表現する"ことをテーマに作品を募っていた。世界中から応募
があり、ひと月程の審査期間を経て、約10倍の確立で我々含め27組の作家が選ば
れ、作品をつくることになった。

PROJECT② YOIGOMA

Long ago the Tosa area of Shikoku Island gave birth to sake cups, known as "bekuhai," that, once filled, can't be set down unless their contents are completely imbibed. In one instance, this owes to a design in the shape of a mask depicting the face of a "tengu," a legendary creature with a long, protruding nose. The sake is placed in the inverted cup, with the hollow, prominent nose allowing for an ample fill of the intoxicating liquid. But the imbiber is unable to place the cup on a flat surface until it is emptied of its contents. Another common "bekuhai" is designed to resemble "hyottoko," a comical character portrayed as a mask with a mouth puckered and skewed to one side. In this case, the mouth is left as an open hole, and to pour the sake into the cup – and drink – the user must cover the hole with a finger. Both types of "bekuhai" were popularly used as tools of communication on lighthearted occasions when sake flowed freely. I decided to create a "bekuhai" with a contemporary twist. I came up with a cone-shaped design that would have no surface enabling it to be set down unless empty. I also wanted the cup to be spinnable, like a top. In the spring of 2017, development of my envisioned product got underway at D-BROS working in partnership with traditional craftspeople from two prefectures. In autumn 2017 I learned that a call was being raised for participants in the upcoming "Echigo-Tsumari Art Triennale," which was scheduled to take place the following year in Niigata Prefecture, and I began wondering whether it might not be possible for KIGI to participate with something. The call raised was for participants in "Hojoki Shiki," the main exhibition to take place at KINARE, the Echigo-Tsumari Satoyama Museum of Contemporary Art. "Hojoki" refers to a collection of essays written in the early 13th century by Kamo no Chomei, a poet who chose to live modestly as a recluse, and for this exhibition the organizers were calling for works that would embody "the universe of ten-foot square huts created by architects and artists." Would-be participants answered the call from all over the world, and after a month-long screening process 27 artists, approximately 1 in 10 applicants, were chosen, KIGI among them.

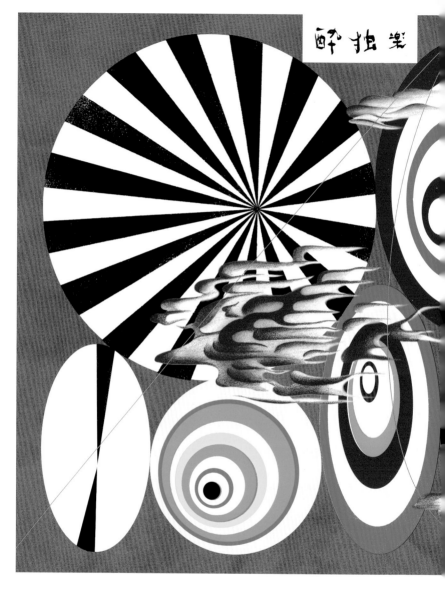

酔独楽

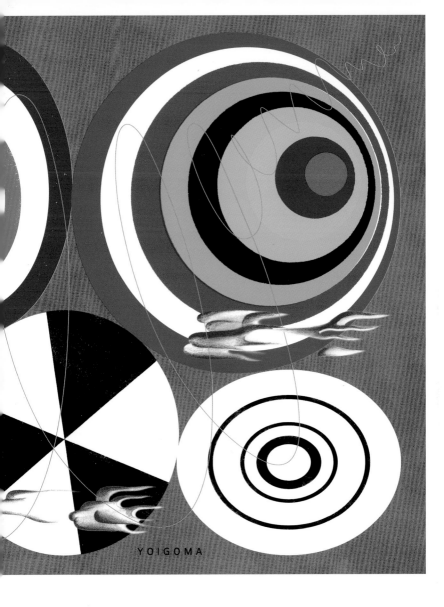

YOIGOMA

日本では酒蔵数、消費量ともに日本一の新潟県。僕は「酔が回れば独楽も回る」というキャッチコピーを考え、開発中の「酔独楽（よいごま）」を使った「スタンディング酒BAR」を体験型の作品として表現してみようと考えた。さらに、開催地にある酒蔵「津南醸造」と組んで、その蔵で一番美味しいお酒をこの作品のために新しい装いでパッケージングし、BARで提供すると同時に商品として販売する運びとなった。また、参加者（BARのお客さん）への提供の仕方や、スタッフの衣装やメイク、空間のデザイン、WEBサイトやポスター等をつくり、全てのコンテンツをゼロから生み出すことでKIGIの"作品"とし、芸術祭への参加につなげた。BARでは、お客さんはお金を支払いサイコロを振る。出た目によって盃の大きさと酒の等級が決まる。酒を注ぐ女性のバーテンダーが、このためにつくった専用の独楽回しなどを使って盃を回し、回り終わるまでの少しの間、盃が回る姿をお客さんに楽しんでもらう。バーテンダーはその間、拍子木を叩く。拍子木の大きさも盃の大きさにあわせて変化する。そんな仕組みになっている。また、酔うことでぐるぐる目が回り、同時に盃が回るイメージを、盃のデザイン、酒のパッケージ、空間のグラフィック等でそれぞれ表現している。

アートディレクターという立場で芸術祭に参加することの意義としてこのように考えた。
① 普段の延長線上にあるクリエイションを極めて自然な形で表現すること。
② 盃＋酒＋BARという複合的な「酔独楽」ブランドという実態をつくり、（思いの）発動 → ものづくり → 発信 → 運営、その全てを手がけること。

この2つを必要最低条件として考え、作品制作のプロジェクトを遂行していった。また（公募の）テーマへの回答としては、酒を通じて日本の文化を広げていくことを目的とし、また酔うことで現実から離れていく世界を"方丈から広がっていく宇宙"として表現した。さらに外へ外へ広がり、社会へ浸透していくことを1つのゴールとして（2021年現在）KIGIのライフワークとして活動しているアートプロジェクトである。

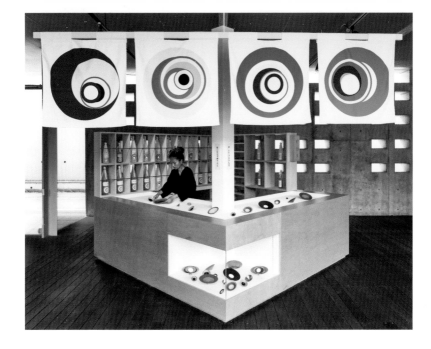

Niigata Prefecture ranks first in Japan in terms of number of sake producers and volume of sake consumption. For my work, I chose to create a real-life standing sake bar where patrons would use the spinnable sake cups under development, which I had named "yoigoma," or "drunken tops." For my catchphrase I came up with "when the head spins, so too does the top." In addition, I tagged up with a local sake producer, Tsunan Sake Brewery, to serve its most delicious sake in my standing bar. It also evolved that we would sell that sake, in newly designed packaging, on the premises. I additionally devised how we would serve our customers (the exhibition participants), what the bar staff would wear and their makeup, the spatial design, a website, a poster, and so on. All of these original items would constitute KIGI's "work" created for the Art Triennale. At the bar, after paying their money the patrons would roll dice. The number rolled would determine both the size of their sake cup and the grade of sake they would receive. The barmaid would spin the cup using a device specially made for this event, and the patron would have fun watching the spinning until it was over, all the while as the barmaid would provide "accompaniment" by rhythmically keeping time banging a pair of wooden clappers. The size of the clappers too would be determined according to the size of the sake cup. And to represent both how the sake cup spins and how the imbiber's head starts spinning under the effects of the drink, images suggestive of these sensations were designed into the sake cups, the sake packaging, and the spatial graphics.

We thought there was meaning in participating in an art festival as an art director, in two respects.
First, it gave us an opportunity to express ourselves creatively, in an extremely natural form, as an extension of what we ordinarily do. Second, by creating the "yoigoma" brand integrating sake cups, sake and a bar, we would complete the entire process from conception to crafting, to promotion, to operation.

Considering these as the minimal conditions necessary, we proceeded to undertake our creative project. In addition, in response to the theme of the exhibition, we aimed through sake to spread Japanese culture. And we also expressed "the universe beyond ten-foot square huts" achieved when inebriation distances us from reality. Furthermore, with one goal being to expand further and further, penetrating ever-deeper into society, this is an art project that, today in 2021, has for KIGI become a lifelong pursuit.

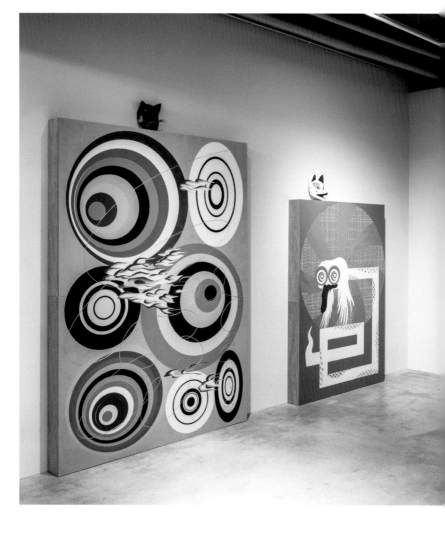

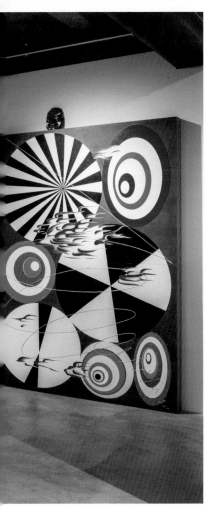

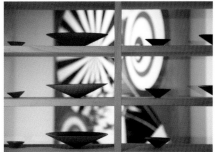

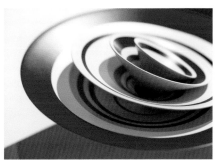

2020年1月に行った展覧会「祝いと酔独楽」は、KIGIの運営するギャラリーであるOFS Galleryで開催された。
この展覧会では、「祝い」をテーマにパフォーマンスを考え、新年の書き初め体験、日本の妖怪をイメージした
ドローイング作品、巨大盃等を追加し、少し進化したかたちで展開した。

In January 2020 we held an exhibition titled "Celebration and Yoigoma" at OFS Gallery, which is operated by
KIGI. For that event, to provide an element of performance on the theme of celebration, we added such features
as having participants write their first calligraphy for the new year, make drawings depicting Japanese ghosts
and the like, and we also added a giant sake cup. This took our original project parameters one step further.

ABCDEFGHIJKLMN OPQRSTUVWXYZ!? abcdefghijklmnopq rstuvwxyz 1234567 890.,:;

T.O.D.A.

AS IF WORKING WITH A GARDEN TROWEL...
UNTIL 50 YEARS OR SO AGO, THERE WAS A BEAUTIFUL FOREST HERE. IT WAS AN OPEN FOREST, ITS UNDERGROWTH NEATLY CLEARED. AND THE FRIENDLY GAZE OF A DISTANT HAND WAS ALWAYS IN EASY VIEW. FIREWOOD WAS GATHERED AND CHARCOAL MADE, AND IN RETURN SPECIAL CARE WAS TAKEN TO KEEP THE FOREST HEALTHY. THIS IS HOW IT WAS FOR YEARS AND YEARS AND YEARS. THE FOREST WE SEE IN NASU TODAY WAS PLANTED. MAN-MADE FORESTS NEED TO BE TENDED OR THEY BECOME DARK AND OVERGROWN. THOSE WHO KNOW THE BEAUTIFUL FOREST OF EARLIER TIMES KNOW THAT TODAY THE FOREST IS DYING.

LET'S MAKE THE FOREST OPEN, AGAIN

NOT BY FELLING TREES WANTONLY IN THE VIOLENT WAY OF DECADES PAST. BUT IN A WAY THAT LETS PEOPLE EXPLORE THEIR RELATIONSHIP WITH THE FOREST AGAIN. WE CLEARED SOME ACRES IN THE FOREST WITH LOVE AND CARE, AS IF WORKING WITH A GARDEN TROWEL, TO CREATE A PLACE FOR PEOPLE TO GATHER. THEN WE SCULPTED SOME UNUSUAL PLACES AND GENTLY SET THEM DOWN AMIDST THE TREES.

WE HOPE VISITORS WILL COME AND MARVEL AT THE WILD FLOWERS' HUES, THE INSECTS' SOUNDS AND DEW SPARKLING ON SPIDER WEBS. FOR WE BELIEVE ONLY WITH SUCH SENSITIVITY CAN THE BUD OF HOPE APPEAR TO RESTORE THE RELATIONSHIP BETWEEN FOREST AND MAN. WHETHER WITH CLICKS OF THE MOUSE, PEERING THROUGH A CAMERA LENS, OR CREATING A SKETCH ON CANVAS - WHATEVER SUITS YOUR FANCY - WE INVITE YOU TO COME AND SEE OUR FOREST IN ALL ITS BEAUTY.

As if working with a garden trowel...

Until 50 years or so ago, there was a beautiful forest here. It was an open forest, its undergrowth neatly cleared, and the friendly gaze of a distant hand was always in easy view.

Firewood was gathered and charcoal made, and in return special care was taken to keep the forest healthy. This is how it was for years and years and years.

The forest we see in Nasu today was planted. Man-made forests need to be tended or they become dark and overgrown. Those who knew the beautiful forest of earlier times knew that today the forest is dying.

Let's make the forest open, again.

Not by felling trees wantonly in the violent way of decades past, but in a way that lets people explore their relationship with the forest again.

We cleared some acres in the forest with love and care, as if working with a garden trowel, to create a place for people to gather. Then we sculpted some unusual PLACE and gently set them down amidst the trees.

We hope visitors will come and marvel at the wild flowers' hues, the insects' sounds and dew sparkling on spider webs. For we believe only with such sensitivity can the bud be restore the relationship between forest and man.

Whether with clicks of the mouse, peering through a camera lens, or creating a sketch on canvas - whatever suits your fancy - we invite you to come and see our forest in all its beauty.

制作：くさぶえ・T.O.D.A.

Boutique!

Boutique!
Thinking about fashion, through art

Fashion is indispensable to our lives, both as a way to express ourselves and as what we wear every day. Spiral will host a special exhibition re-examining fashion through artworks created by partnerships of artists and fashion designers.

The exhibition features emerging talents from Finland and Japan, with a diverse range of video, sculpture, painting, and installation exploring themes of price vs. value, production vs. waste, function vs. decoration, and society's criteria for "beauty".

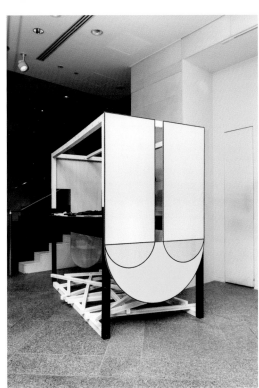

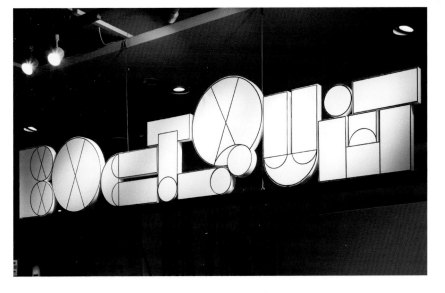

Une vieille mélodie que quelqu'un m'a donné 1

Janvier___Approche, Approche 2

Février___Une petite ferme avec bergerie, basse-cour, 3

quatre ruches et un pigeonnier

Mars___Mélusine transformée en dragon 4

Avril___Fiançailles 5

Mai___Cavalcade 6

Juin___Les mains 7

Juillet___Songe d'été d'un mouton 8

Août___Parure de robes 9

Septembre___Le château de Saumur figé dans le temps 10

Octobre___La chanson de l'épouvantail 11

Novembre___A l'orée de la forêt 12

Décembre___Sonner l'hallali 13

Le presque-rien inoubliable 14

Les Très Riches Heures du Duc de Berry 15

Théâtre
MUSICA

Plus Beau Du Monde

石川直樹
この星の光の地図を写す
Saturday, January 12, 2019
—Sunday, March 24, 2019
Tokyo Opera City Art Gallery

Naoki Ishikawa
Capturing the Map of Light on This Planet

東京オペラシティ アートギャラリー
2019年1月12日〈土〉ー2019年3月24日〈日〉

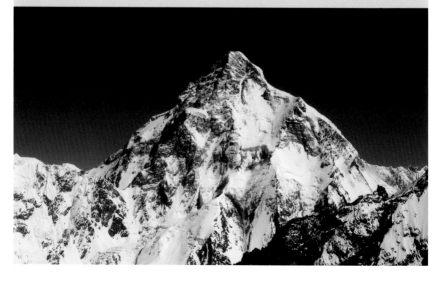

石川直樹
この星の光の地図を写す
Saturday, January 12, 2019
— Sunday, March 24, 2019
Tokyo Opera City Art Gallery

Naoki Ishikawa
Capturing the Map of Light on This Planet
東京オペラシティ アートギャラリー
2019年1月12日〈土〉— 2019年3月24日〈日〉

石川直樹
この星の光の地図を写す
Saturday, January 12, 2019
— Sunday, March 24, 2019
Tokyo Opera City Art Gallery

Naoki Ishikawa
Capturing the Map of Light on This Planet
東京オペラシティ アートギャラリー
2019年1月12日〈土〉— 2019年3月24日〈日〉

石川直樹
この星の光の地図を写す
Saturday, September 8, 2018
— Sunday, November 4, 2018
Kitakyushu Municipal Museum of Art
Riverwalk Gallery

Naoki Ishikawa
Capturing the Map of Light on This Planet
北九州市立美術館分館
2018年9月8日〈土〉— 2018年11月4日〈日〉

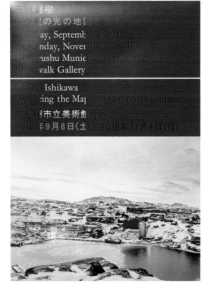

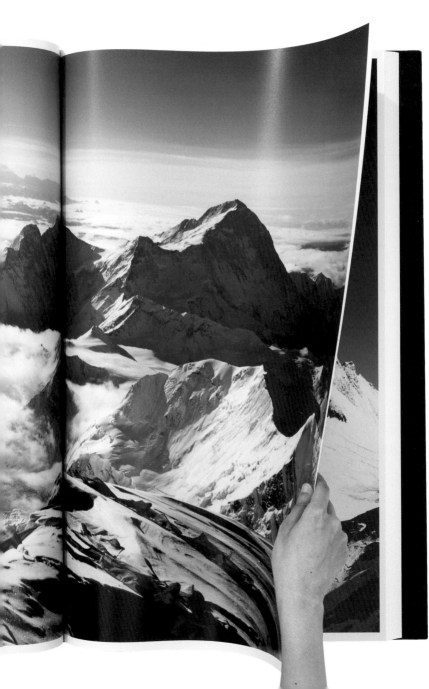

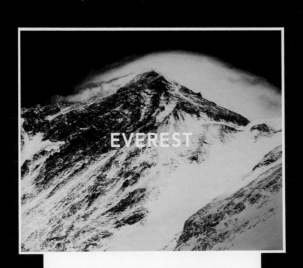

EVEREST

NAOKI ISHIKAWA

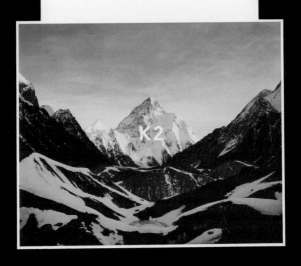

K2

PROJECT③　D-BROS／カレンダー

1995年に株式会社DRAFTが立ち上げたプロダクトブランド・D-BROSのプロジェクトに僕は1999年からDRAFT
の社員として参加することになった。グラフィックデザインの世界に新しい風を送りたいとDRAFTの代表である
宮田識さんが立ち上げたこのプロジェクトは、初めは1冊のカレンダーを作り、企業に販売するところから始まっ
たと聞いている。当時カレンダーというものは、年末に企業が配るものとしてよくつくられていて、商品としては
ステーショナリーコーナーの売り場で多少販売している程度だった。これといって珍しいものはなく、名画や風
景、またはアイドルのカレンダー等が多かったと思う。D-BROSのカレンダーはその小規模なマーケットに入り
こんで、少しずつ売り場の景色を変えていった。スマホの影響で紙製品全体が売れなくなってきた近年までは、
年末に近づくにつれカレンダーの売り場が特別につくられ、メーカーは競い合い、多種多様なデザインのカレ
ンダーが販売され、売り場も充実するようになっていた。僕は1999年から本格的にD-BROSの商品を増やして
いくためにプロジェクトの中心メンバーとなり、これまで（2021年現在）約20を超えるカレンダーのデザインを
発表してきた。

PROJECT③　D-BROS / CALENDAR

Starting in 1999, as an employee of DRAFT Co., Ltd. I began participating in the D-BROS product brand project
launched by DRAFT in 1995. As I understand it, the project was inaugurated by DRAFT President Satoru Miyata
in a quest to breathe new life into the realm of graphic design. The project started with creation of a calendar
that DRAFT planned to market to corporate clients. In those days businesses often produced original calendars
to distribute at year's end. Calendars to be sold on a commercial basis were relatively few, found mostly in
shops and sales departments specializing in stationery goods. There was nothing especially unu sual about the
calendars of those times, and as I recall many featured reproductions of famous artworks, beautiful landscapes,
or the latest popular young celebrities. D-BROS's calendars made inroads into this small commercial market and
gradually brought changes to their sales venues. Until recent years, when paper products as a whole have faded
in popularity under the impact of the smartphone, in-store calendar sales areas were specially set up with the
approach of the year's end, producers vied vigorously, and calendars of highly diverse designs were marketed.
Sales flourished. In 1999, I became a core member of a project created to expand D-BROS's calendar lineup in
earnest. To date (2021) we have designed more than 20 original brand calendars.

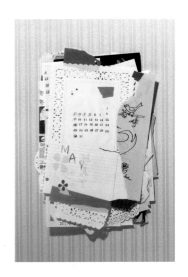

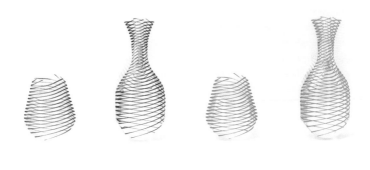

PROJECT③　D-BROS ／フラワーベース

2002年に開発し、2003年から売り始めた水を入れると自立するビニールのフラワーベース「hope forever blossoming」は、我々の予想を上回るロングセラー商品となり、毎年新しいデザインを発表してこれまで（2021年現在）90種類を超えるデザインを生み出してきた。この商品は、シャンプーの詰め替え用パッケージの構造を利用したもので、生活用品のパッケージを主につくっている工場へ発注した。紙モノの印刷とは違った様々な制約があり、それらを加味した上でのデザインということもあり、1stデザインはシンプルなストライプにした。（その単純さは結果的にこのプロダクトの特徴を引き出すことになったと思っている。）「フラットなビニール素材の袋が水を入れることで花瓶に変わる」というアイデアを伝えるには、複雑なデザイン、尖ったデザインだと表現が主張し過ぎて伝わりづらい。"普通"が"普通ではない"ことをデザインする難しさがこのプロダクトにはあった。アイデアを考えるきっかけを与えてくれたのは渡邉だった。僕が作業机に放置していた水の入ったシャンプーのパッケージに、会社の中庭から摘んだ一輪の花を挿したのが渡邉だったのだ。ちょっとしたユーモアで行ったその行為から2人で商品の可能性を探し、さらに半年後、熱圧着によってかたちを成形できることを、とあるきっかけで思いつき、2003年の春この商品が完成した。

PROJECT③　D-BROS ／カップ＆ソーサー

フラワーベース「hope forever blossoming」と平行して開発を行なっていたのが、カップ＆ソーサー「MIRROR」。この2つの商品の特徴は、平面が立ち上がるところにある。この考え方は、D-BROSの商品開発の1つの軸となり、その後生まれてくる商品に大きな影響を与えることになる。「MIRROR」は、鏡を使った騙し絵からヒントをもらって、アイデアやデザインを考え、商品化につなげた。その騙し絵は、フラットな歪曲した絵がセンターに置かれた円筒状のミラーに映り込むことで認識可能な絵が浮かび上がる。僕はこの構造で何かできることがないかと考え、その構造が日常的に"普通"にあるものが相応しいと思い、カップ＆ソーサーに辿り着いた。この商品も渡邉とともにデザインを進め、2003年の春に商品化し、その後もシリーズ化して2021年現在まで、5種、30デザインを発表した。

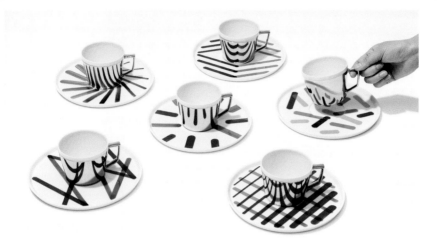

PROJECT③ D-BROS / FLOWER VASE

"hope forever blossoming," our plastic flower vases which stand erect when filled with water, have sold steadily over time, beyond our expectations. Developed in 2002 and first marketed in 2003, the lineup of designs has been expanded every year, and to date (2021) we have designed more than 90 varieties. Because the vases employ the same structure as a shampoo refill pack, we ordered their production at a plant that mainly makes packaging for everyday items. For the vases' initial design we chose simple stripe patterns. This choice was made in consideration of various constraints stemming from differences from printing on paper. Ultimately, I think this simplicity served to play up the product's uniqueness. A complex or edgy design would have put too much stress on the design per se, thus weakening the ability to convey the novel idea that a flat plastic container could transform into a vase. The difficulty with this product was designing something "out of the ordinary" for something essentially ordinary. I got the idea for "hope forever blossoming" from something Yoshie did quite casually. One day I left a shampoo refill pack, filled with water, on my desk at work, and Yoshie placed a flower in it that she had picked in the company's small inner courtyard. Out of this small gesture by Yoshie just to be amusing, we began probing possibilities for a product. About half a year later, it occurred to me that it might be possible to create shapes by thermocompression bonding, and in the spring of 2003 the product was finalized.

PROJECT③ D-BROS / CUP & SAUCER

In parallel with development of the "hope forever blossoming" flower vases, I also developed a line of cup and saucer sets known as "MIRROR." What these two products share is a design that creates three-dimensional perceptions from inherently flat surfaces. This feature became central to D-BROS product development, and it has had a strong influence on the brand's subsequent offerings. In developing "MIRROR," I took a hint from a trompe l'oeil illusion created with use of a mirror. In the trompe l'oeil in question, a flat, distorted image became a clearly recognizable picture when reflected in a cylindrically shaped mirror placed at the center. I pondered various ideas and designs, thinking how I might work them up into a product. I ruminated on what I might possibly be able to create using such a visual mechanism, and eventually I decided that it would work best in something "ordinary" that we use every day. That's how I came upon the idea of a cup and saucer set. I proceeded in the design phase in collaboration with Yoshie. Our first commercial product was completed in spring 2003, and since then, as of 2021 we have developed a series of cups and saucers that now includes five varieties encompassing a total of 30 designs.

DB

			1	2		
~~3~~	~~4~~	~~5~~	~~6~~	7	8	9
~~10~~	11	12	13	14	15	16
~~17~~	18	19	20	21	22	23
~~24~~	25	26	27	28	29	30
~~31~~						

May

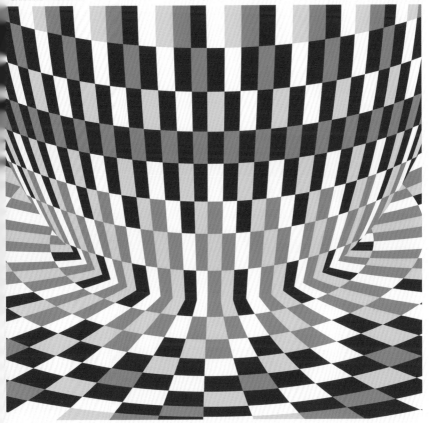

D-BROS
ORIGINAL PRODUCTS

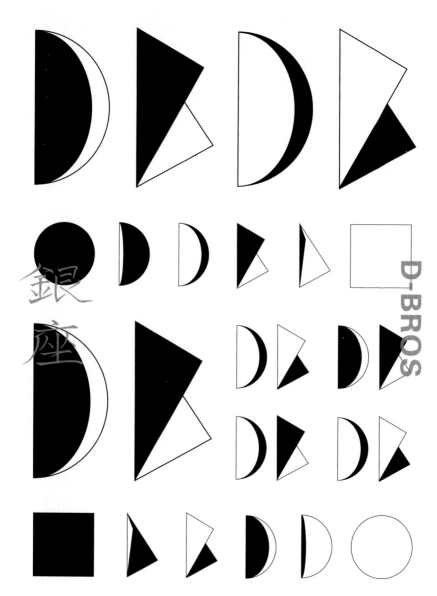

D-BROS_GINZA JAPANESE TRADITIONAL & CONTEMPORARY DESIGN

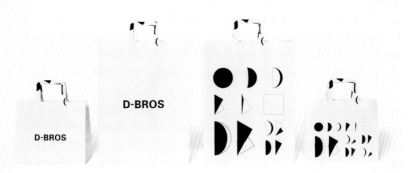

 CANTUS

àcôté

àbcdéfghijklmn
Ôpqrstuvwxyz@
1234567890／.,:;!?

1-7-5, nishihara, shibuya-ku,
tokyo, 151-0066, japan
telephone. +81(0)3-6873-7623
acote@tj8.so-net.ne.jp
www.facebook.com／acote.tokyo／

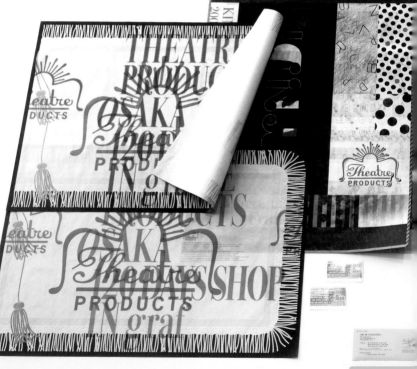

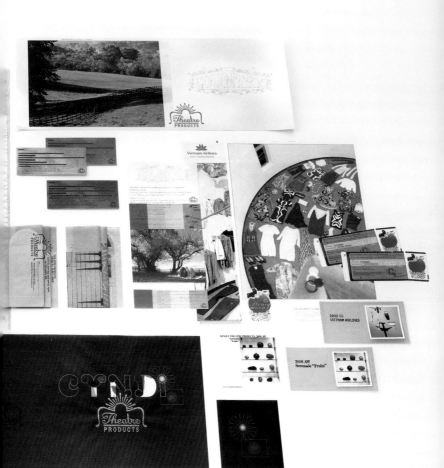

PROJECT④　OUR FAVOURITE SHOP

2015年7月に東京・白金にオープンしたOUR FAVOURITE SHOPは、クリエイティブと社会（エンドユーザー）との接点をつくり、アート、デザイン、工芸、音楽、食などの文化を発信することを目的として、KIGI、bluestract、丸滋製陶の3社によって運営している。商店街から少し住宅地の中に入った場所にあり、KIGIがデザインしたプロダクトを中心に物販をするショップスペースと、様々なクリエイターを応援する場としてギャラリースペースをつくり、毎月、展覧会や物販の展示販売等を企画しながら、地元に根付いた活動をしている。OURは"私たち"でもあり、私たちの周りの"みんな"でもある。

We are rooted in the earth. We are rooted in the earth and we are looking up at the sky. We receive a blessing from the sky. It tells us we can keep growing. This is the shop we love. We would love you to love it too. OUR FAVOURITE SHOP

PROJECT④ OUR FAVOURITE SHOP

OUR FAVOURITE SHOP was opened in the Shirokane area of Tokyo in July 2015 to serve as a venue where creative artists and their works could have direct contact with the public – their end users. Jointly operated by KIGI, bluestract and Marushi Porcelain, OUR FAVOURITE SHOP aspires to disseminate culture in all its various aspects: art, design, crafts, music, food, etc. The shop is situated in a residential area close to a shopping zone. It consists of two parts: a commercial space where mainly products designed by KIGI are sold, and a gallery space that functions as a place to support an array of creative artists. Every month exhibitions are held, many offering their displayed items for sale. Today, OUR FAVOURITE SHOP has put down solid roots in its local community. This is why "OUR" refers both to us and to everyone around us.

GRAPHIC TRIAL 2009 - Repetition on Surface

"Graphic Trial" is an experiment in which I pursue the rerationship between graphic design
and printing expression in depth in order to acquire new expressions.

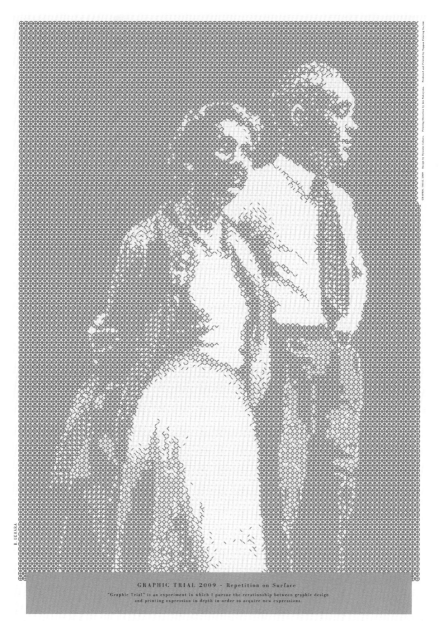

R. UEHARA

GRAPHIC TRIAL 2009 - Repetition on Surface

"Graphic Trial" is an experiment in which I pursue the rerationship between graphic design
and printing expression in depth in order to acquire new expressions.

PROJECT⑤　プライベートワーク

プライベートワークをKIGIの活動として僕が重要に思っている理由の1つは"つくることに慣れてはいけない"と思っていることだ。デザインはやればやるほど上手くなり、早くもなる。ただ、魅力的なものにはどこか不器用さ、そして荒々しさがあると思う。だから慣れてはいけないと、ときどき自分に言い聞かせている。少しずつ自分のクリエイションの扉を開け、新しい世界を体験することが次の新しいクリエイションにつながっていく。

2つ目の理由を山登りに例えると…登ったこともない山を登ってみたい。そこから眺める見たこともない景色を見てみたい。僕らクリエイターにとっては不思議なことではないだろう。見たこともない作品をつくるということは一番高い山に登ることでもある。ただ、一番高い山でヤッホーと叫んでみてもこだまは跳ね返ってこない。なぜならば、近くに反響する山がないからだ。芸術作品はひとまずそれでもいいだろう。

PROJECT⑤ Private Work

One reason why I believe creating private works is an important part of KIGI's activities is because I think it isn't good to become overly accustomed to making things. The more one designs, the better – and faster – one becomes at it. Yet, I think that truly attractive works have elements of imperfection, of roughness. And so I occasionally remind myself that it isn't good to become too accustomed to what I'm doing. Gradually opening one's creative door and experiencing a new world will lead to the next new creation.

The second reason can be compared to mountain climbing. We want to climb mountains we have never climbed before. From there we want to see vistas that we have never seen before. This isn't something strange for those of us doing creative work. Creating a work never seen before is to climb one's highest mountain. But from that highest peak, even if we attempt to call out in expectation of hearing our echo, nothing bounces back to us. This is because there are no mountains nearby to return our call. In the arts, that's okay. But for a designer, there is no work without a mountain to respond to our call. In other words, even if you climb to the highest mountain peak, to seek an echo you have to descend the mountain. Then you look for the echo that suits your project. It may be many small echoes,

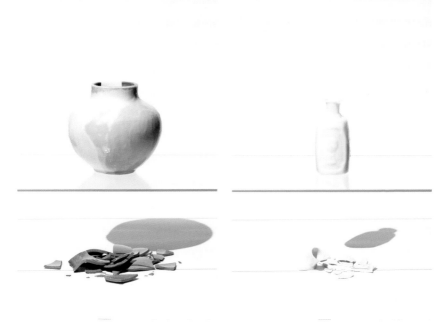

一方で、デザイナーは反響する山がないと仕事にならない。つまり、もし一番高い山の頂上に登ったとしても、こだまを探すために下山しなければならない。そして、そのプロジェクトにあったこだまを探す。沢山の小さなこだまかもしれないし、1つの大きなこだまかもしれない。デザインの仕事の面白さはこの繊細な作業にある。もちろんクライアントも含め、協働作業なので、チームを編成して到達地点の狙いを定めてプロフェッショナルに人々を牽引する。それには山を知らないといけない。だから一度頂上に登ってみる。そして、確実に少し下山をする。

3つ目の理由は野球に例えてみる。僕にとってのプライベートワークは"素振り"だと思っている。"本番試合"に備えた素振り。素振りはホームランをイメージして、またはクリーンヒットをイメージしてバットを振る。制限はない。一方で本番試合には、仲間がいて、ルール、時間に制限があり、さらにお客さんがいる。まさにこれは僕にとってのデザインの仕事。つまり素振りは、試合に備えたイメージトレーニングなのだ。

そういった理由等から、実験的な作品づくり（プライベートワーク）はとても重要だと思っている。渡邉と一緒につくる作品もあれば、1人でコツコツとつくる作品もある。2017年に行った大規模な宇都宮美術館での個展では、数こそはデザインの仕事が多いけれど、スペース的にはプライベートワークが2/3を占め、それまでの蓄積した作品を発表させていただいた。現代美術のトップアーティストたちがつくるような壮大な作品はないが、僕らなりに追求した（小さな）高い山で大きく素振りしたものたちだった。

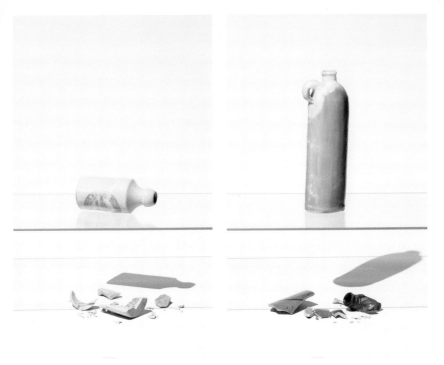

or it may be one large one. It's this delicate process that makes the job of a designer interesting. Of course, since it's a collaborative job that includes your client, you have to put together a team, set the point you aim to arrive at, and lead the others in a professional manner. To do so, you have to understand mountains. That's why you climb to the peak, to see what it's like. And then you come down a little.

The third reason can be compared to baseball. To me, creating private works is like taking practice swings: swings of the bat practiced in preparation for the actual game. You swing the bat with a mental image of hitting a home run, or scoring a clean hit. There are no limits. In a real game, you have teammates, rules, time limitations, and people watching you play. This is precisely what the job of designing is like for me. Practicing my swing is my image training in preparation for the game.

It's for reasons such as these that I think creating experimental works – private works – is so important. Some works I create together with Yoshie, and some I plod along making them on my own. At KIGI's large-scale exhibition at the Utsunomiya Museum of Art in 2017, in terms of numbers our design works were most numerous; but in terms of occupied space, our private works accounted for two-thirds of the space allotted. We showed works we had accumulated up to then. Although there were no grand works of the kind made by the top contemporary artists, what we showed were our big practice swings taken atop a (small) high mountain.

悲しくも
人間はふたつの目を持つけれど、自分の顔を見ることができない。
自分を知りたい、自分を見つめたい
と、鏡になるひとを探すのだ。

悲しくも
人間は身体というひとつの狭い部屋に閉じ込められている。
孤独な身体から脱け出したい、誰かと繋がりたい
と、心と心を通わせるのだ。

悲しくも
人間の命には期限がある。
痕跡を残したい、自分の輪郭をみつけたい
と、自我が生まれたのだろう。

そしてコミュニケーションが始まった。

幸せを予感し、成功と繁栄をイメージし
心と心、知識と知識、情報と情報、技術と技術
これまで様々な**交換**がなされてきた。

交換のスピードは
留まることなく次第に加速度を上げ
やがて特異点へと向かう。

ところが人類の進化と繁栄とともに
長い歴史の中でなされてきた**交換**は
次第に混ざり合い、同じような国、同じような文化
同じような考えをもつ平均的な人間を多く生み出してきてしまった。

エントロピー増大。"平衡状態に向かう万物の自然な現象"は
意図して秩序を生み出すことのできる人類でさえも
大きな時間軸のなかで、いつの間にかこの現象に
流されているかのようにみえる。

悲しくも
繁栄とともに
国や文化や人における"個性の消失"を運命づけられているようだ。

繋がる幸せと個性の消失はイコールなのだろうか?

Sadly,

we have two eyes yet cannot see our own face.

That's why we always look for "mirrors" that reflect ourselves,
wishing to find who we are and how we look, inside them.

Sadly,

we are confined into our own small body.

That's why we always reach out to other people, wishing to free ourselves
from our lonely bodies, to connect with the hearts of others.

Sadly,

our life is limited.

That's probably why we develop our ego,
wishing to leave traces on this world, carve our outline of self.

The beginning of communication.

Expecting happiness, imagining success and prosperity,
we've been **exchanging**
feeling, knowledge, information, technique.

The **exchange** never stops,
rather accelerating and
finally, reaching "singularity."

However, in the long course of human evolution,
this **exchange** has brought not only prosperity,
but also homogenous countries, cultures, and people with homogenized ideas.

"Entropy enhancement"
— the universal law that directs all nature toward equilibrium states.
Even human beings with their will for order are not immune to this law,
irresistibly drifting toward it in the long stream of time.

Sadly,

in exchange for prosperity,
our collective and personal "individuality" may be destined to be lost.

Does the happiness of connection equal the loss of individuality?

ひとし降りてくる水の「水」は、地球を巡ってわしゅのいのちとなる
また、幸せを運び、時には荒て、やがて天に還る
「水」という水は、地球の血液みたいなものかもしれない

私は「水」の扉を探す旅に出る

Water is a gift from the sky.
It falls upon and runs through the earth, nourishing all living things.
It sometimes blesses and at other times ragus.
And eventually, it returns to the sky.
Water is the lifeblood of the earth.

I embark on the journey to search for the gate to water.

#001 35°08'27.7"N 139°09'36.6"E 16:56:40 30, June, 2019

私たちが生まれる遥かむかし、「水」は「鏡」を映し出し、ひとは自分を知るしかけうたのでうか

Imagine if, long before we were born,
water reflected us and we could see ourselves in it.

Manazuru, Manazurucho, Ashigarashimogun, Kanagawa, Japan

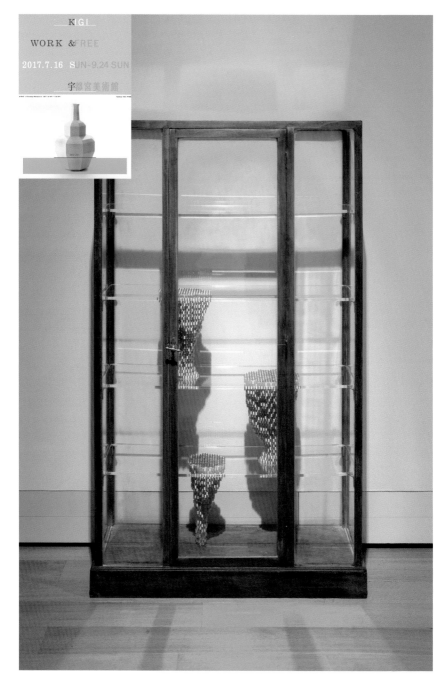

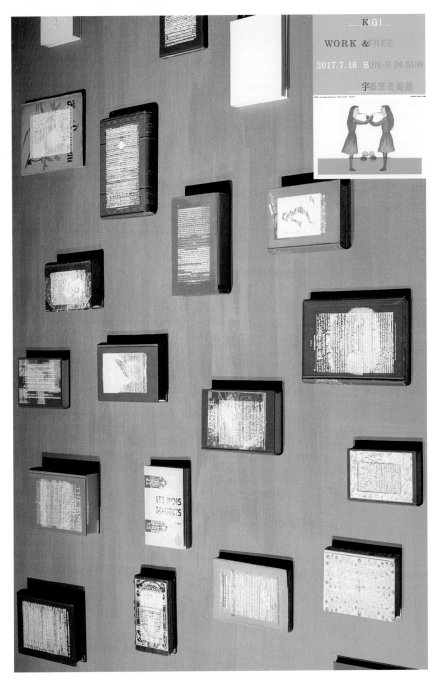

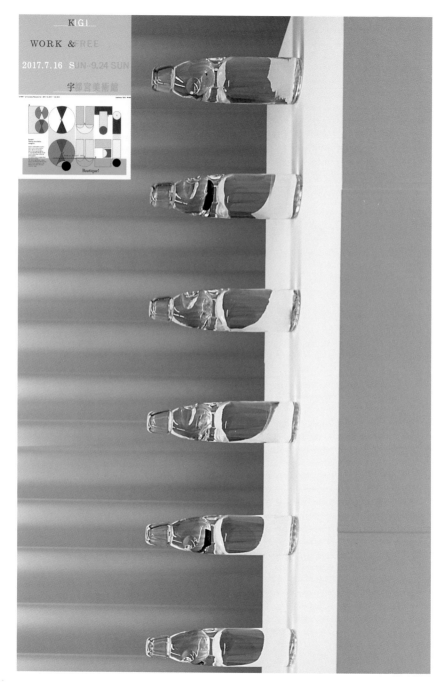

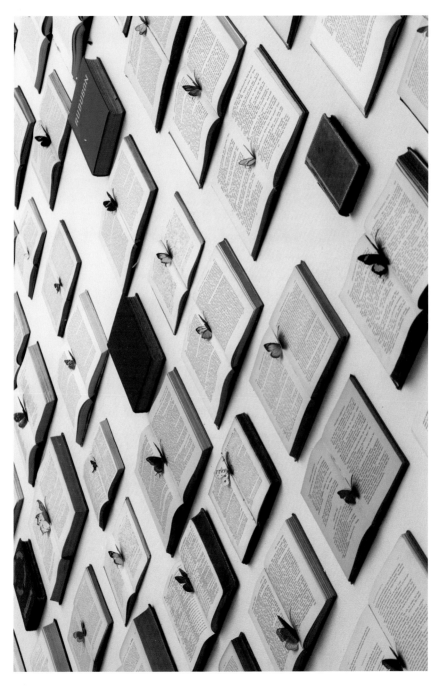

List of Works

植原亮輔 / Ryosuke Uehara

1972年北海道生まれ、多摩美術大学卒。DRAFT Co., Ltd.を経て2012年に渡邉良重と共にKIGI Co., Ltd.を設立。企業やブランドのアートディレクション、グラフィックデザイン、空間ディレクション、プロダクトデザインのほか、アートプロジェクト等にも参加。展覧会やイベント等を企画しながらクリエイションの"場"を作る活動も行う。

Born in Hokkaido in 1972. Graduated from Tama Art University. After working for DRAFT Co., Ltd., he established KIGI Co., Ltd. in 2012 together with Yoshie Watanabe. In addition to his core work in corporate and branding art direction, graphic design, space direction, and product design, he also takes part in art projects. He is also active in designing creative spaces and in planning exhibitions, events, etc.

Major Works and Awards

D-BROS product design (1999-) *Tokyo ADC Award (2000/2003), New York ADC Gold (2004), JAGDA Award (2010)

CASLON Bakery & Cafe (Sendai) (1999)

JAGDA New Designer Award (2001)

MIHARA YASUHIRO fashion brand invitation (2002) *Tokyo ADC Award, Young Gun Gold (2002)

Laforet Harajuku Annual Image Advertising (2005) * Warsaw International Poster Biennale Silver Medal (2006)

THEATRE PRODUCTS fashion brand season visuals (2006-)*11th Yusaku Kamekura Design Award (2009), Tokyo TDC Prize (2009)

Toppan Printing Graphic Trial "Repetition on Surface" poster (2009) *New York ADC Silver (2010)

PASS THE BATON select recycle shop (2009-) *JAGDA Award (2010)

"implosion ↔ explosion"exhibition (2012-2013) *New York ADC Gold, One Show Design Gold Award (2013), One Show Design Silver Award (2014)

Mori Wo HirakuKoto, T.O.D.A. (facility complex in Nasushiobara) (2012) * Tokyo ADC Members' Award (2013), JAGDA Award (2013)

Clematis no Oka (cultural complex in Shizuoka) 10th anniversary planning (2012)

Merchandise for Every Little Thing's "On 'N' On" tour (2013) *Tokyo TDC Prize (2014), JAGDA Award (2014)

RuQ brand products of Okinawa (2013-)

"BOUTIQUE!"exhibition at Spiral (2014) *Tokyo TDC Prize (2016), D&AD Awards Wood Pencil (2015)

KIKOF product brand (2014-) *Tokyo ADC Grand Prize (2015)

"MERRY BOOK ROUND" app (2014) *JAGDA Award (2015)

Opening of OUR FAVOURITE SHOP (gallery & shop) (2015-) *JAGDA Award (2016)

Naoki Ishikawa exhibition "Capturing the Map of Light on This Planet" (2016-2019)

D-BROS at GINZA SIX (shop operated by D-BROS) (2017-2020) * Tokyo ADC Members' Award (2017)

"Oya, Stone City" (web portal of Oya area of Tochigi Pref.) (2019)

"Shiseido Styles" exhibition at Takashimaya (2019)

Interior artwork at InterContinental Yokohama Pier 8 (2020)

"GINZA! GINZA! GINZA!" 2nd anniversary of Shiseido at THE GINZA (2020)

New packaging design for RAFRA brand skin care products (2021)

Major Exhibitions

"Chocolate" (21_21 DESIGN SIGHT, 2007)

"Ryosuke Uehara Exhibition: The 11th Yusaku Kamekura Design Award Winner" (Creation Gallery G8, 2009)

"KIGI Exhibition: Ryosuke Uehara and Yoshie Watanabe" (ginza graphic gallery, 2012)

"KIGI Exhibition: implosion ↔ explosion" (Hillside Forum, 2013)

"ONE OFF DESIGN" (PASS THE BATON, 2014) *JAGDA Award (2015)

"KIGI EXHIBITION in Fukuoka"(Art Gallery Mitsubishi Estate Artium, 2015)

"KIGI in Clematis no Oka" (Clematis no Oka / Vangi Sculpture Garden Museum, 2016)

"KIGI WORK & FREE"(Utsunomiya Museum of Art, 2017)

"Yoigoma: The Standing Sake Bar" (artwork for "Hojoki Shiki"at Echigo-Tsumari Art Triennale 2018) *Tokyo ADC Members' Award (2019)

Publications

"KIGI" (2012)

"KIGI_M_001_private work", "KIGI_M_002_product", "KIGI_M_003_graphic" (2016)

"KIGI_M_004_now and before" (2018)

*Books are in Japanese only unless otherwise noted. All of the above are published by Little More.

植原亮輔 / KIGI（世界のグラフィックデザイン 131）

発行	2021年3月22日
	公益財団法人DNP文化振興財団
定価	本体 1,165円（税別）
企画・制作	公益財団法人DNP文化振興財団
デザイン	植原亮輔 / 森本麻友
翻訳	室生寺 玲
販売	株式会社DNPアートコミュニケーションズ
	〒141-8001　東京都品川区
	西五反田3丁目5-20
	TEL.03（6431）3708
印刷・製本	大日本印刷株式会社
プリンティングディレクション	渡辺慎也

RYOSUKE UEHARA / KIGI（World Graphic Design 131）

Publication	March 22, 2021
	DNP Foundation for Cultural Promotion
Price	¥1,165（Tax not included）
Design	Ryosuke Uehara / Mayu Morimoto
Translation	Rei Muroji
Sale	DNP Art Communications Co., Ltd.
	5-20 Nishi-Gotanda 3-Chome,
	Shinagawa-ku, Tokyo 141-8001
	Tel. +81-3-6431-3708
Printing & Binding	Dai Nippon Printing Co., Ltd.
Printing Direction	Shinya Watanabe

https://www.dnpfcp.jp/foundation/
ISBN978-4-88752-403-3
©2021 RYOSUKE UEHARA Printed in Japan
用紙＝サテン金藤 四六 / 150kg